D0903107

DRAWING MADE EASY

EASY 1 ANIMALS

Felix Lorenzi

Bay Books

Sydney and London

The *Drawing Made Easy* series
Volume 1, Animals
Volume 2, People
Volume 3, Perspective
Volume 4, Nature

This edition © 1984, Bay Books Pty Ltd, Sydney and London
Publisher George Barber
ISBN 0 85835 759 3

© 1979 Boje Verlag

Preface

At first, a child draws his world with great imagination and without inhibitions. However his scribblings may actually appear, he is delighted, and it seems that for him, his drawing is a reflection of his own ideas and expectations. During this developmental phase, the adult's role is above all to encourage the child and his efforts.

But there comes a time when the child becomes artistically inhibited, critical and unsure of his own work: the success he had earlier is no longer there. Whereas before he firmly believed that he had drawn *his* horse or *his* dog correctly, he now suddenly has the feeling that he can no longer draw anything properly. Often he will turn to an adult, asking him to draw him a dog, a cat, a hen, a rabbit, or whatever. But, unfortunately, the adult frequently gives up disheartened after drawing the first lines. He feels it is too much for him and suddenly becomes unsure of what the requested object actually looks like. Even if he uses a photograph, he somehow seems unable to draw properly. How many of us have had this experience? It is primarily with such experience in mind that this book has been written. But it is also for people who, for whatever reason, have decided that they really ought to try and learn to draw properly.

When a child, disappointed with his own efforts, seeks adult advice about drawing the time is ripe to begin systematic instruction. This is the point at which the decision can be made as to whether the child will continue to enjoy drawing or whether he should give it up for good. The method set out in this book is particularly suitable for children. The introduction has been written simply, so that even a ten-year-old can read it without difficulty. Then he can try — perhaps in competition with his parents — to faithfully reproduce on paper his favourite pet. Drawing is by no means a form of art which should be left to the highly talented. First and foremost, drawing means looking at things and trying to understand them: how is an animal really constructed? Which parts are the most important? Knowledge increases with an understanding of these 'how?' questions. And it is 'how' that forms the foundation of the drawing method outlined here in *Volume 1: Animals*. Step by step, you will learn how a horse, a goose, or a rabbit can, when viewed simply, be divided up into individual body parts and then drawn.

Drawing teaches you to see and observe. If you wish to draw you must first learn to see. You must be able to recognise the relationships between different shapes and then draw them. Drawing is merely the art of transferring the three dimensions of the visible world onto a two-dimensional surface — paper.

In today's world it is not always easy to be active and creative. The constant inundation by optical stimuli makes it

3

very difficult to retain an appreciation for, and enjoyment of, the diverse but less obtrusive forms of nature. Against this background, even the most modest drawing assumes significance as a personal achievement; it can lead to inner satisfaction and relaxation, but also to a kind of self-realisation, irrespective of the level of perfection attained in the drawing.

There is another important fact to remember — drawing is one of the many different forms of play. It is a game with shapes, surfaces, darkness and light. And it is a game with one's own abilities.

Surely that appeals to everyone!

Instructions

The world around us is full of objects — animals, plants, cars, people, rivers, houses, fields and mountains. You see their relationship with one another — you see life. Frequently you would like to be able to record on paper your impressions and encounters, you would like to be able to draw or paint. But when you actually try, you realise it is more difficult than you thought.

If you use the following simple method you can learn step by step how to draw the external shapes of your favourite animals more quickly and, above all, more accurately. But to do this it is necessary to have a system which will simplify their shapes and parts. Every object, every living creature, is made up of various basic shapes. Take the horse as an example. This is what a 'real' horse looks like:

Figure 1

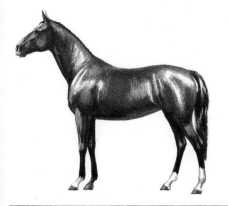

'Where do I start? With the tail, the head, the belly, or the eyes?' You won't get very far with questions like that! First of all, divide the horse into separate geometric shapes. Figure 2 explains what is meant by this:

Figure 2

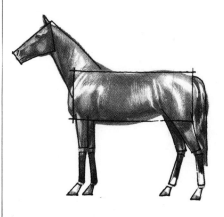

Now you have a geometric model of your horse. It has been divided into simple shapes that are joined to each other and can be drawn with ease. Even the proportions of the individual parts are clear.

The horse in Figure 3 shows the first step. But it is only a lightly drawn preliminary sketch. The pencil lines serve merely to determine the correct proportions.

5

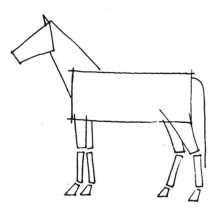

Figure 3

closely, you can memorise many of these basic shapes. Then you can draw things from memory. But wait . . . you're not there yet! Have another look at the horse.

You can vary your first sketch by drawing different positions which are typical of horses. For instance:

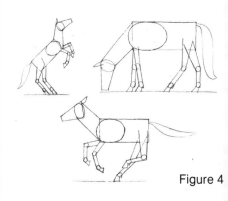

Figure 4

'That's not a horse. It's too simple. This isn't going to be any fun at all!' Oh, yes it is! You see, if you can recognise and find these shapes, you will find everything much easier. And from this geometric, seemingly lifeless preliminary stage you will soon produce a life-like creature. Here, for instance, you see a horse which looks so real you'd think it was neighing at you from the paper!

After this first step in two-dimensional drawing, you should be able to do much better drawings of houses, villages and towns.

Everything in nature has its own basic shape; for example, a horse has longer legs than a cow. A horse proudly stretches its neck upwards; a cow extends its neck horizontally. If you train your eyes, if you look more

Now the horse is no longer stiff and static: it is putting one foot in front of the other and beginning to gallop. Go a step further: look again at Figure 3 and put some life into those stiff geometrical shapes. You can do that by making the neck softer, the belly rounded, the head fuller, and the legs more precise.

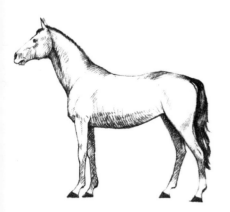

Figure 5

This horse looks much better than the one in Figure 3, doesn't it? But it is still unfinished. It has no eyes, nostrils, or hair, and without ears a horse cannot hear. So now you must add these finishing touches, in the right place and the correct proportions. The hooves ought to be a bit firmer and more exact as well. And where the horse has strong muscles these can be accentuated with shading. In this way, a true horse gradually emerges.

Of course, a great deal of work and practice is necessary before you can draw the proportions accurately. And soon you will no longer be satisfied with a horse based simply on geometric shapes: you will want to go outside, watch a horse in a field, memorise its basic shapes and closely observe its motion. Here is a little piece of advice: never draw with a

ruler, and never measure things. Always use your eyes. It doesn't matter if at first your lines are crooked: with a bit of practice you will soon have no trouble.

Before continuing, take another look at Figure 3. It is a two-*dimensional* drawing — that is, it is constructed from geometric shapes.

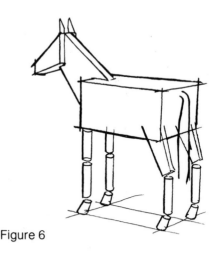

Figure 6

Now turn the horse away a bit, to the right. It becomes a three-dimensional picture! The simple rectangle which forms his belly becomes a body. The neck acquires depth and the head becomes a pyramid without an apex.

The whole horse, from head to foot, gains special dimensions. This three-dimensional portrayal of things is called perspective.

You can now draw three-dimensional space on two-dimensional paper. This provides a new and better way of portraying things: the horse can be drawn much more precisely. His belly is no longer just a rectangle — it becomes possible to see if it is fat or thin.

But even this three-dimensional image of a horse is only a framework that serves to determine the correct proportions. It is time to get a completed, life-like horse from the framework.
Like this:

Figure 7

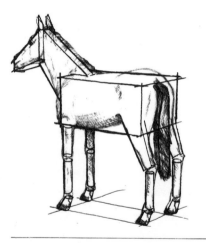

The stiff shapes are dissolved. The edges are rounded off and softened. The neck becomes curved and the belly is now nice and round. And that is the horse completed. It is standing but, since it is a horse, it will not want to do so for long — it will want to start moving its legs. This horse wants to jump about and gallop off!

Have another look at Figure 4. There the horse was standing in various typical positions, although still in the simplified two-dimensional form. Since then you have learnt quite a bit more. Try to draw the horse in various positions, using everything you have learnt so far. The possibilities are endless!

It is particularly important to observe animals in their natural surroundings. There are always new things to see — different movements, different perspectives, different positions — and, thanks to what you have already learnt, you can draw from memory at home. If you draw the movements of different animals, you will become flexible in your drawing and make progress; but if you always show a horse in the same position, you will continue to do things in the same old way — you will draw mechanically, the same things over and over again.

The best paper to use for drawing is one with a fairly rough surface. The pencil should have a soft lead and be held loosely in the hand; it should glide

smoothly and easily over the paper, as if the picture were drawing itself. Don't be impatient with yourself!

Another way of understanding shapes is to model with clay or plasticine. Shapes, as we have seen in the drawings, such as pyramids and cylinders can easily be moulded and stuck together. Once the animal has been modelled in a particular position, it can be drawn from different angles. In this way it is possible to learn even more about three-dimensional objects.

But that's enough theory! It's time to be practical — to start drawing a few familiar household pets.

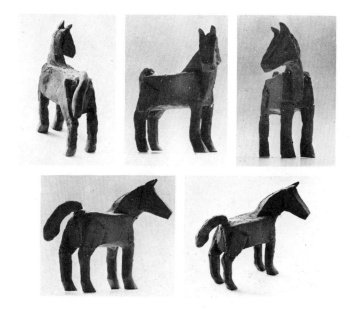

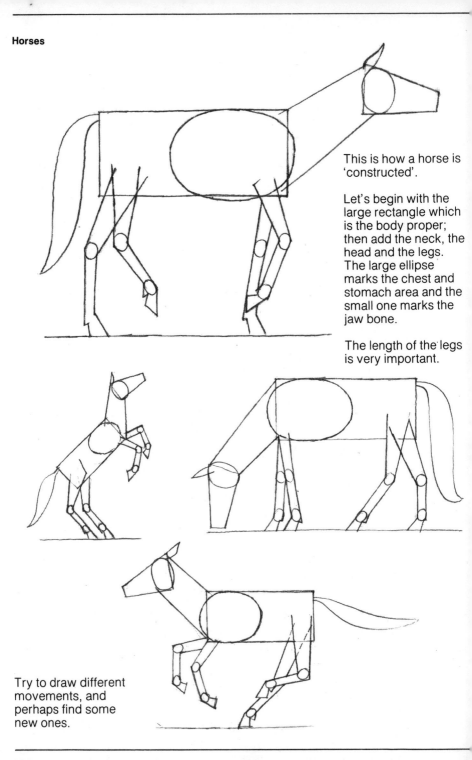

This is how a horse is 'constructed'.

Let's begin with the large rectangle which is the body proper; then add the neck, the head and the legs. The large ellipse marks the chest and stomach area and the small one marks the jaw bone.

The length of the legs is very important.

Try to draw different movements, and perhaps find some new ones.

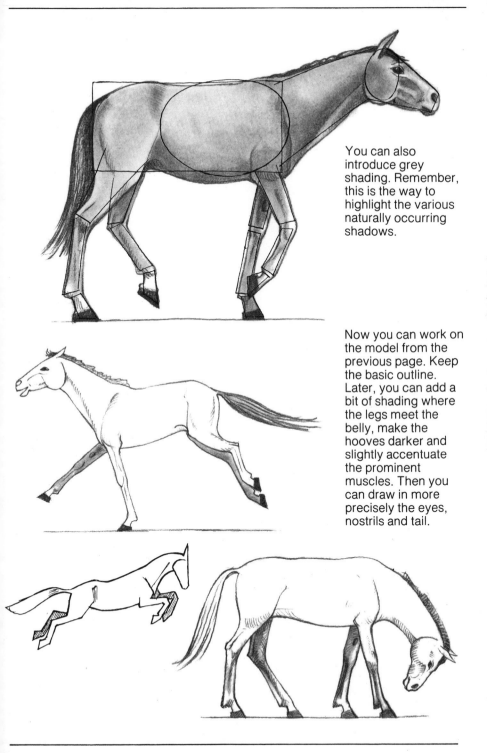

You can also introduce grey shading. Remember, this is the way to highlight the various naturally occurring shadows.

Now you can work on the model from the previous page. Keep the basic outline. Later, you can add a bit of shading where the legs meet the belly, make the hooves darker and slightly accentuate the prominent muscles. Then you can draw in more precisely the eyes, nostrils and tail.

Perspective now becomes involved: the rectangle turns into a cylinder or a brick; the head becomes a pyramid with a cut-off tip; and the legs become long cylinders. This drawing should only be done lightly because it is just the basic sketch for the completed horse.

And here you can try different positions.

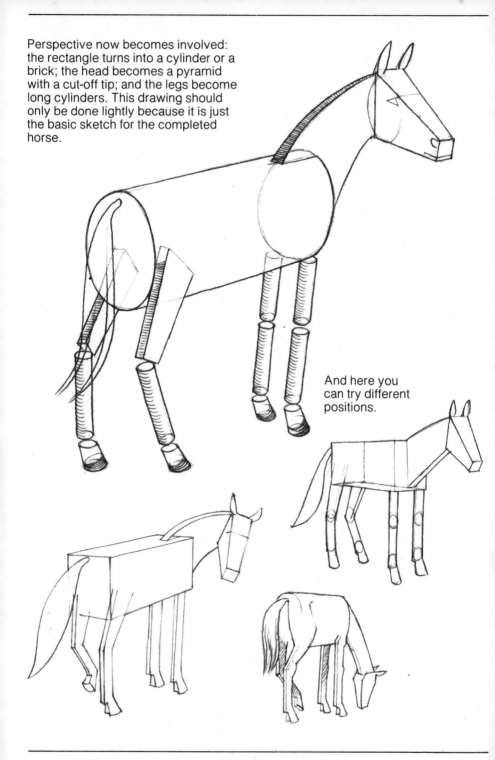

Slowly and with careful attention, you can vary your model. Eyes, mouth and hair can be drawn in more detail.

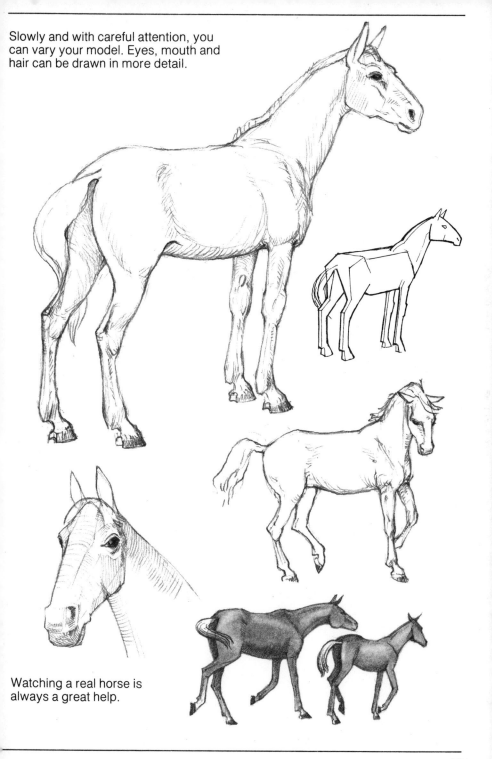

Watching a real horse is always a great help.

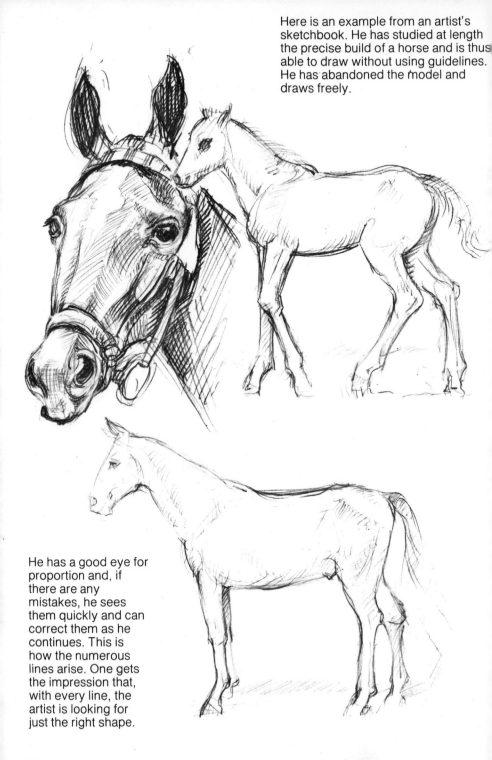

Here is an example from an artist's sketchbook. He has studied at length the precise build of a horse and is thus able to draw without using guidelines. He has abandoned the model and draws freely.

He has a good eye for proportion and, if there are any mistakes, he sees them quickly and can correct them as he continues. This is how the numerous lines arise. One gets the impression that, with every line, the artist is looking for just the right shape.

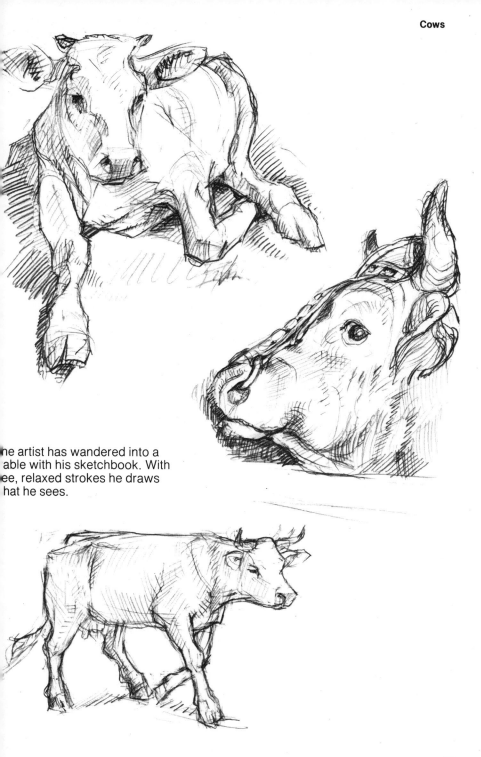

ne artist has wandered into a
able with his sketchbook. With
ee, relaxed strokes he draws
hat he sees.

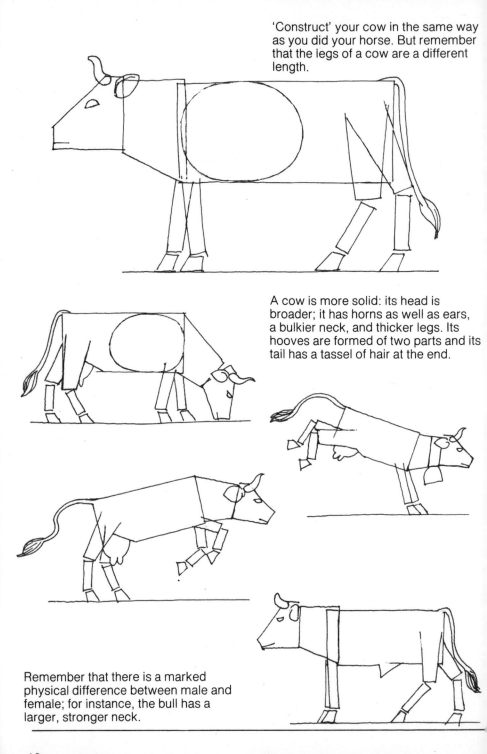

'Construct' your cow in the same way as you did your horse. But remember that the legs of a cow are a different length.

A cow is more solid: its head is broader; it has horns as well as ears, a bulkier neck, and thicker legs. Its hooves are formed of two parts and its tail has a tassel of hair at the end.

Remember that there is a marked physical difference between male and female; for instance, the bull has a larger, stronger neck.

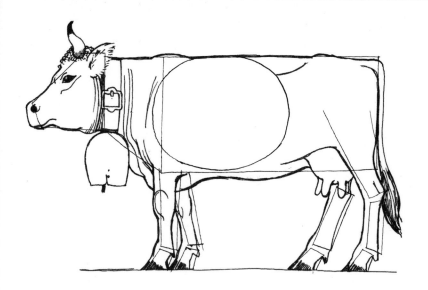

Now you can convert the basic geometric shapes into a completed drawing.

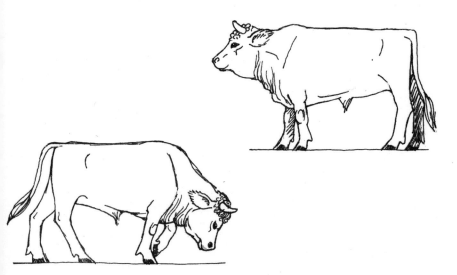

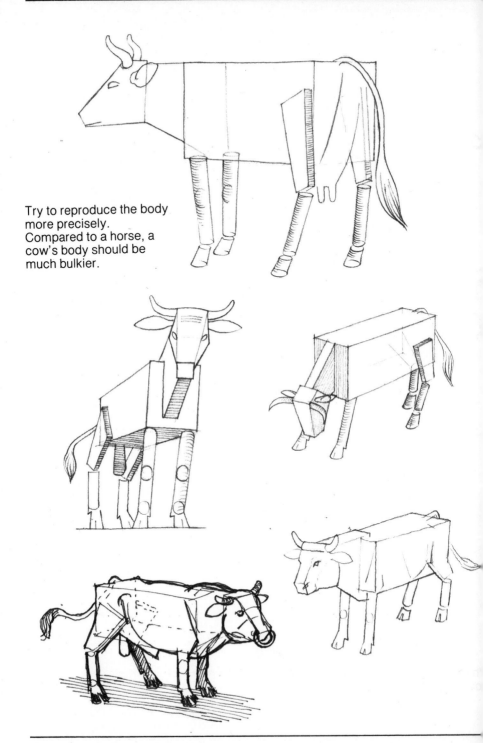

Try to reproduce the body
more precisely.
Compared to a horse, a
cow's body should be
much bulkier.

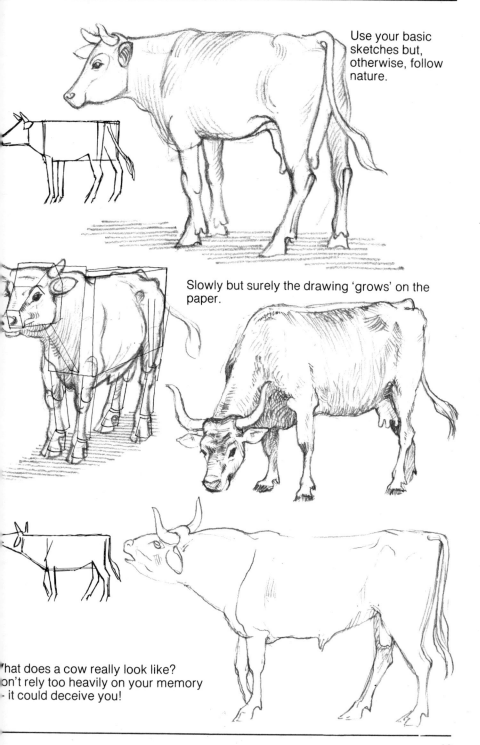

Use your basic sketches but, otherwise, follow nature.

Slowly but surely the drawing 'grows' on the paper.

What does a cow really look like?
Don't rely too heavily on your memory
- it could deceive you!

Donkeys

At first glance, a donkey has the same body shape as a horse. But let's take a closer look. There are differences: the head, the ears and the tail.

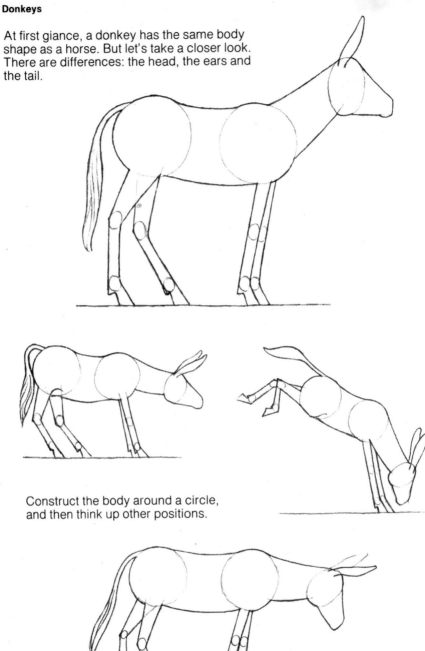

Construct the body around a circle, and then think up other positions.

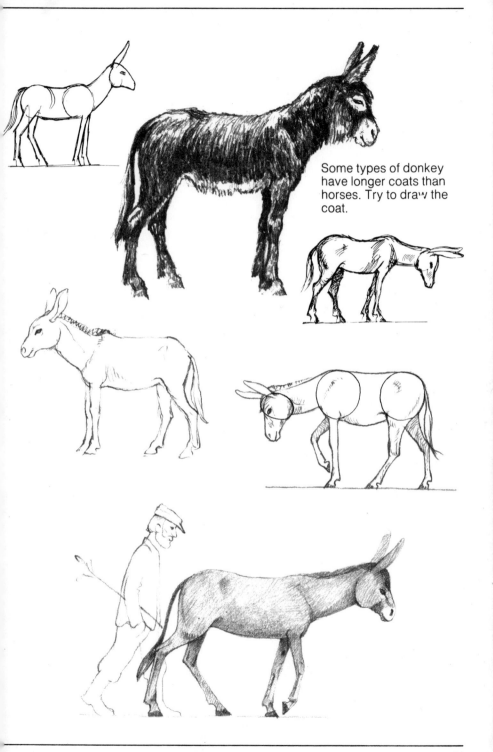

Some types of donkey have longer coats than horses. Try to draw the coat.

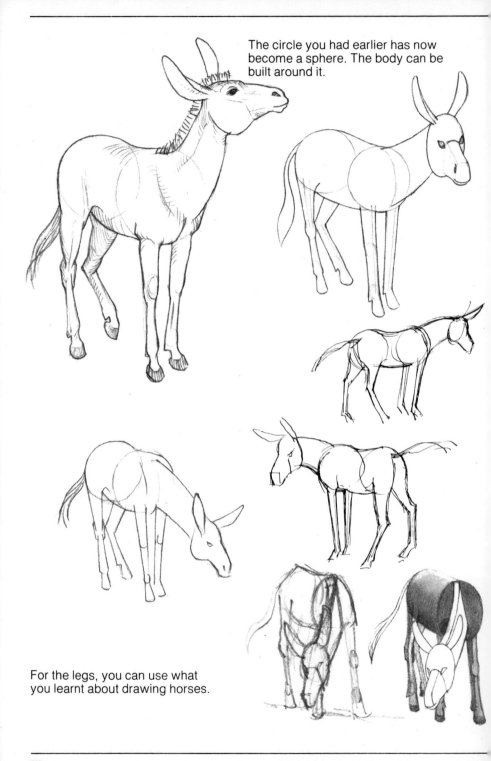

The circle you had earlier has now become a sphere. The body can be built around it.

For the legs, you can use what you learnt about drawing horses.

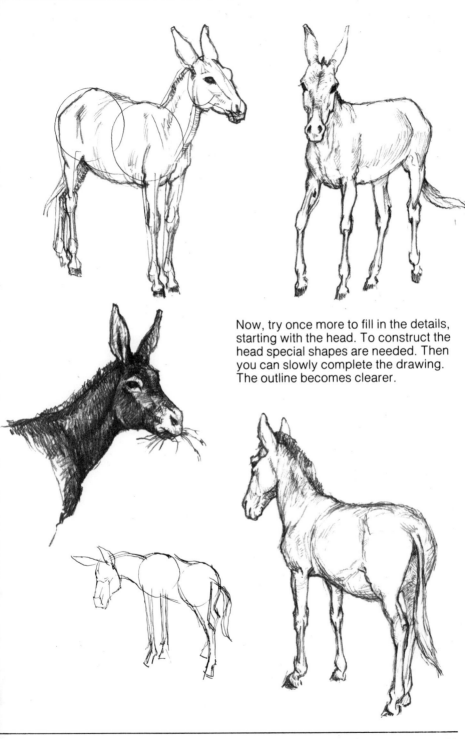

Now, try once more to fill in the details, starting with the head. To construct the head special shapes are needed. Then you can slowly complete the drawing. The outline becomes clearer.

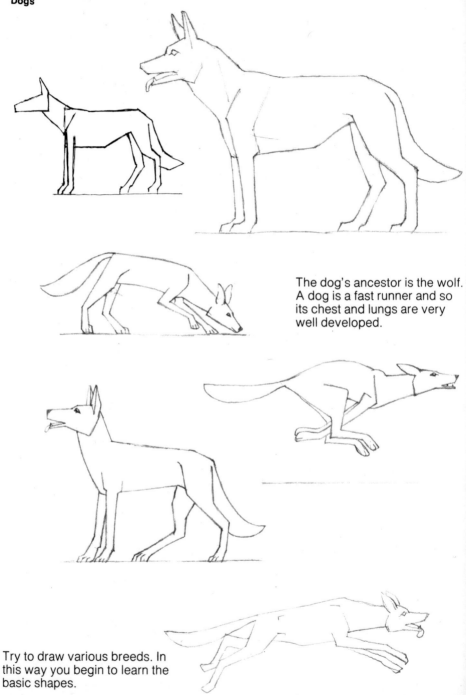

The dog's ancestor is the wolf. A dog is a fast runner and so its chest and lungs are very well developed.

Try to draw various breeds. In this way you begin to learn the basic shapes.

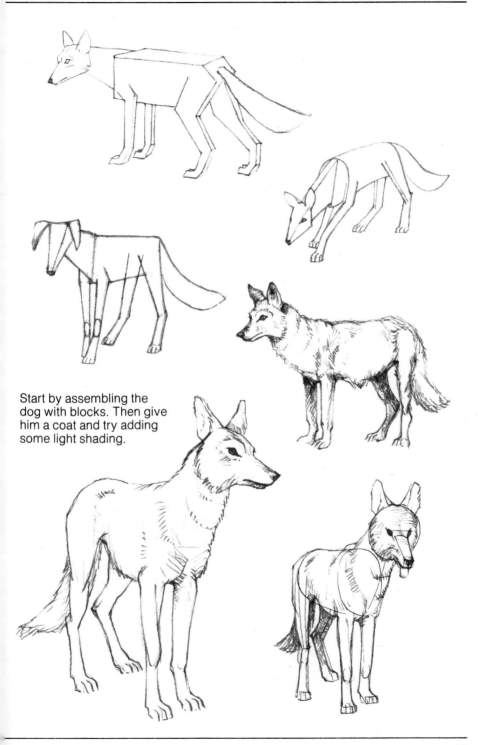

Start by assembling the dog with blocks. Then give him a coat and try adding some light shading.

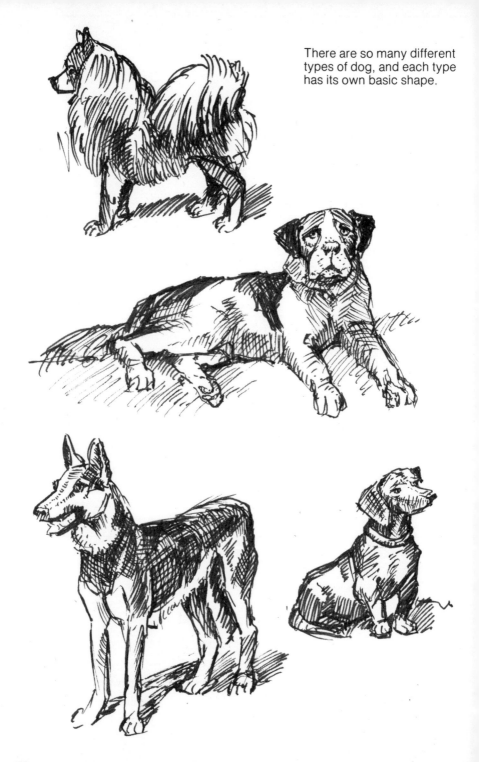

There are so many different types of dog, and each type has its own basic shape.

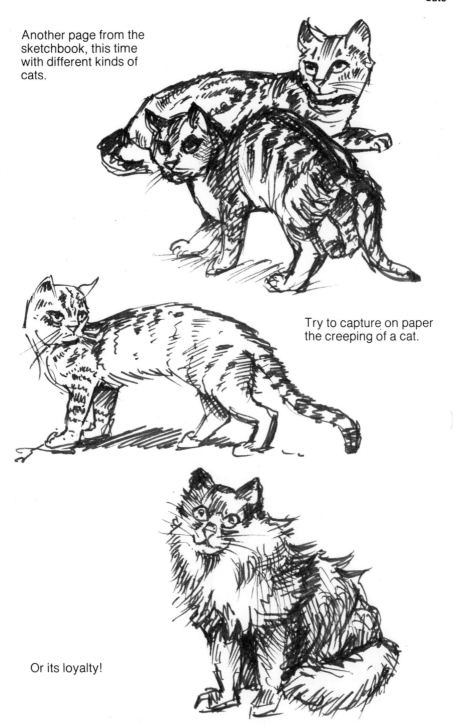

Another page from the sketchbook, this time with different kinds of cats.

Try to capture on paper the creeping of a cat.

Or its loyalty!

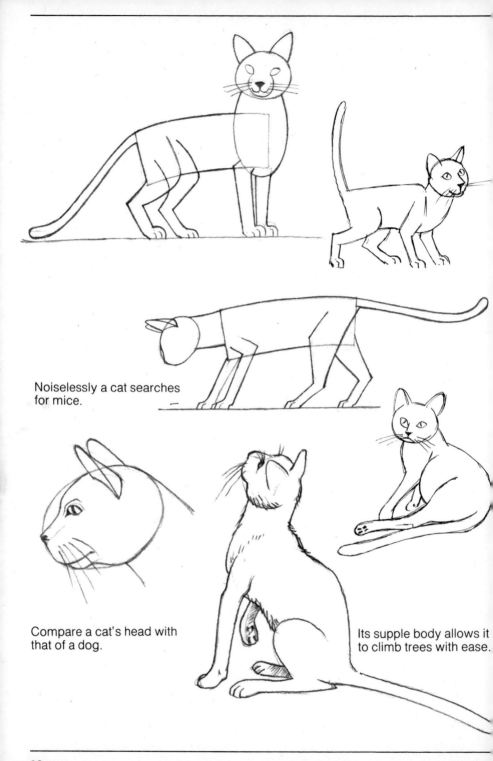

Noiselessly a cat searches
for mice.

Compare a cat's head with
that of a dog.

Its supple body allows it
to climb trees with ease.

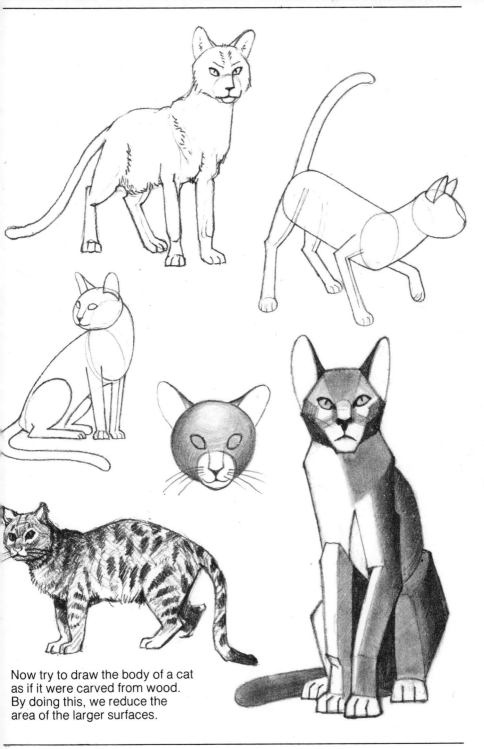

Now try to draw the body of a cat as if it were carved from wood. By doing this, we reduce the area of the larger surfaces.

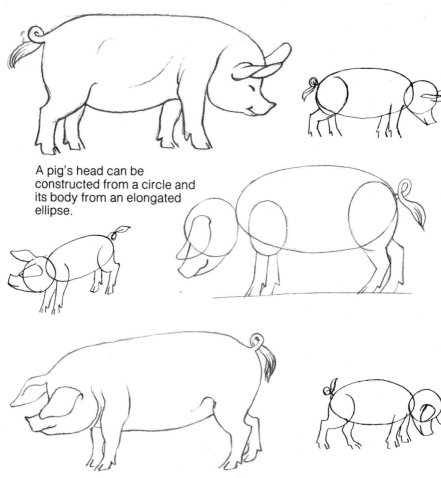

A pig's head can be constructed from a circle and its body from an elongated ellipse.

Pigs have cloven hooves.

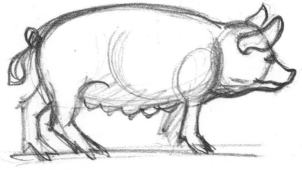

And remember the little curly tail!

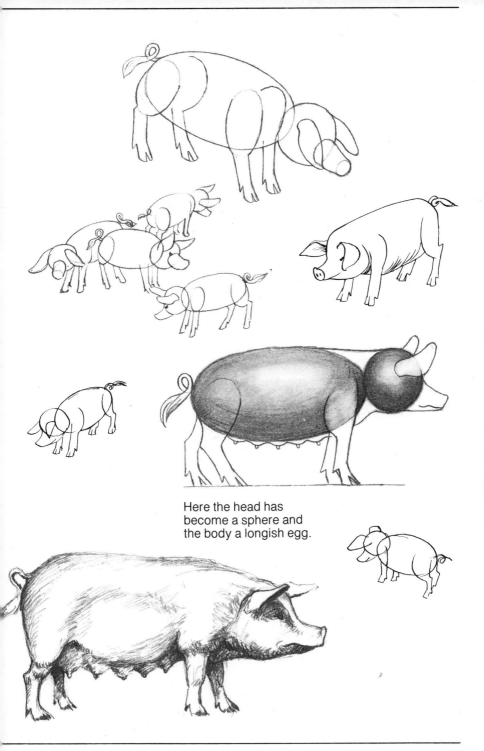

Here the head has
become a sphere and
the body a longish egg.

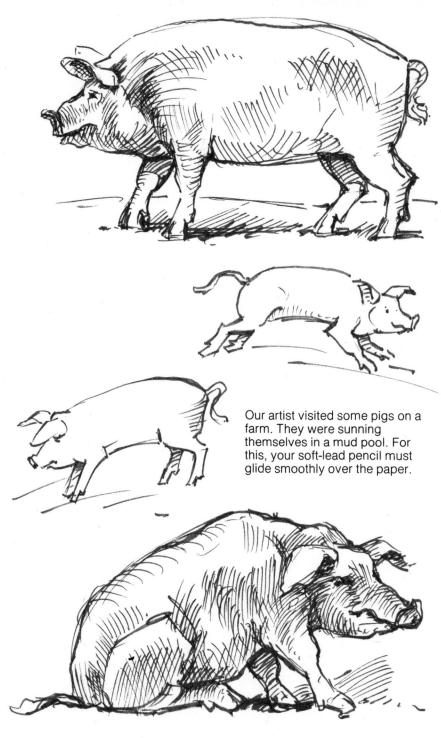

Our artist visited some pigs on a farm. They were sunning themselves in a mud pool. For this, your soft-lead pencil must glide smoothly over the paper.

Sheep in a paddock.

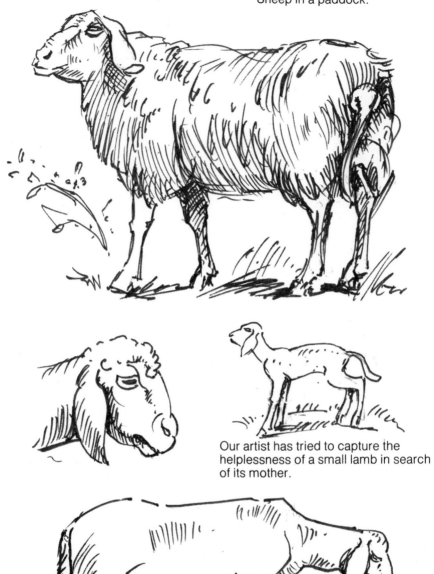

Our artist has tried to capture the helplessness of a small lamb in search of its mother.

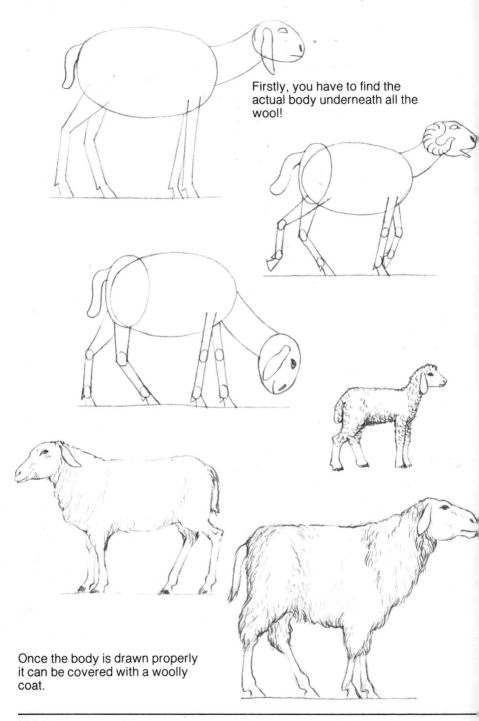

Firstly, you have to find the actual body underneath all the wool!

Once the body is drawn properly it can be covered with a woolly coat.

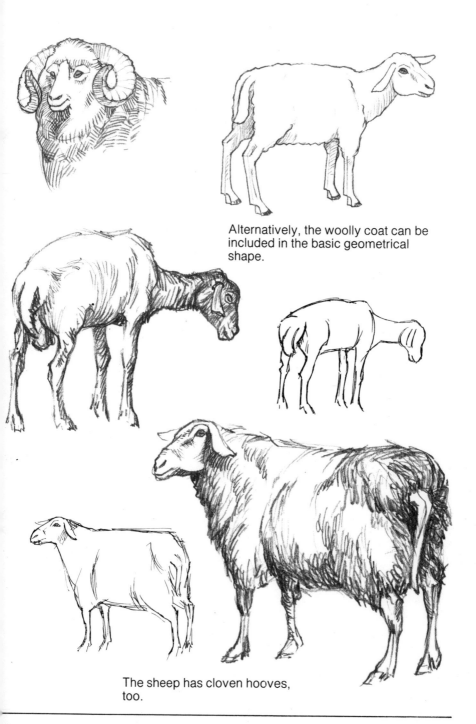

Alternatively, the woolly coat can be included in the basic geometrical shape.

The sheep has cloven hooves, too.

Goats

Goats have much more angular bodies than sheep.

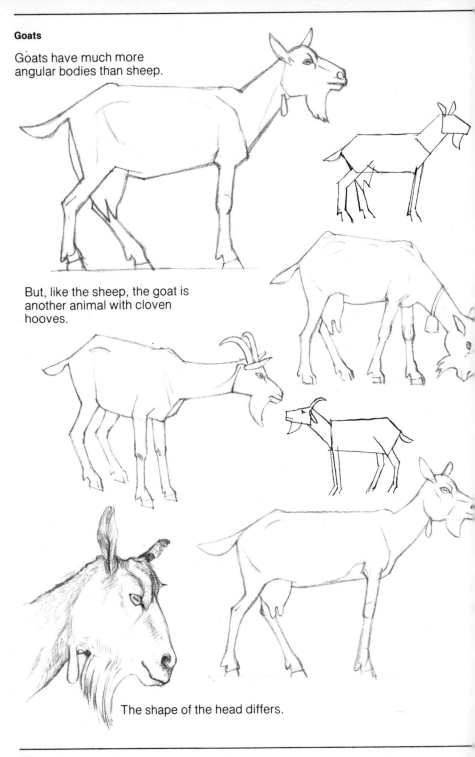

But, like the sheep, the goat is another animal with cloven hooves.

The shape of the head differs.

And this is how you get a three-dimensional picture of a goat. Don't forget the horns and beard!

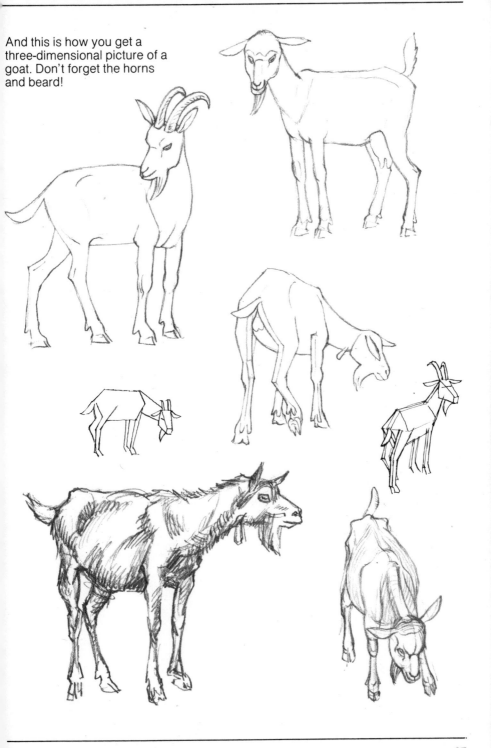

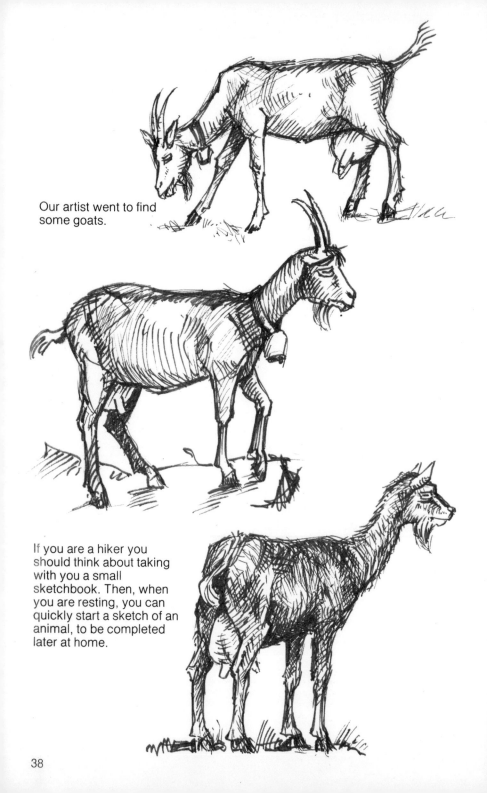

Our artist went to find some goats.

If you are a hiker you should think about taking with you a small sketchbook. Then, when you are resting, you can quickly start a sketch of an animal, to be completed later at home.

A rabbit hutch offers many possibilities for the observant artist who likes discovering new things.

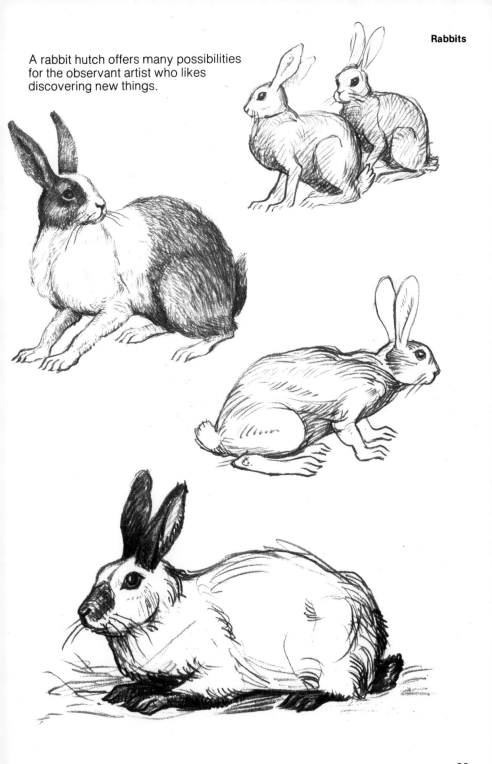

Ellipses will help us to draw
this pretty little creature.

It is just a matter of putting
ellipses of different sizes in
the right order to get our
rabbit.

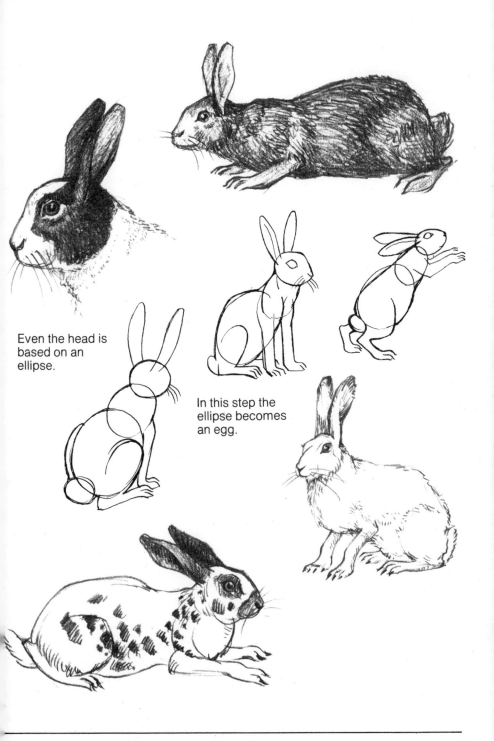

Even the head is based on an ellipse.

In this step the ellipse becomes an egg.

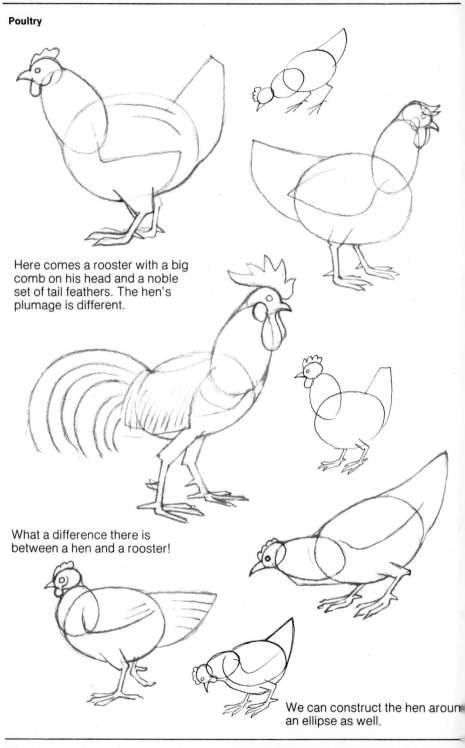

Poultry

Here comes a rooster with a big comb on his head and a noble set of tail feathers. The hen's plumage is different.

What a difference there is between a hen and a rooster!

We can construct the hen around an ellipse as well.

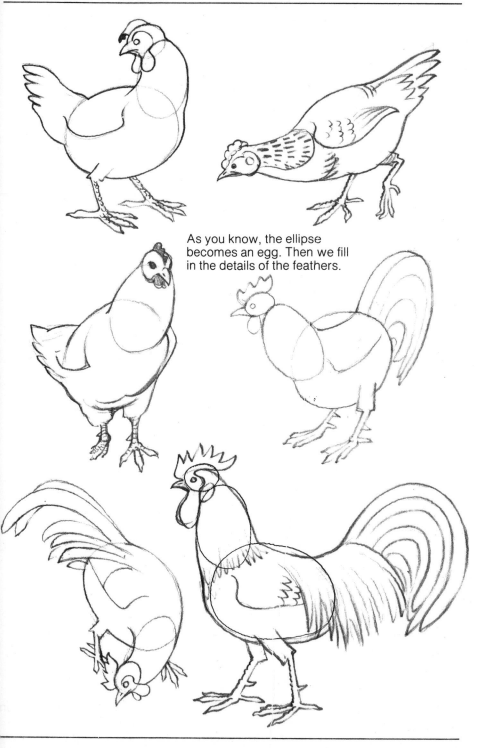

As you know, the ellipse
becomes an egg. Then we fill
in the details of the feathers.

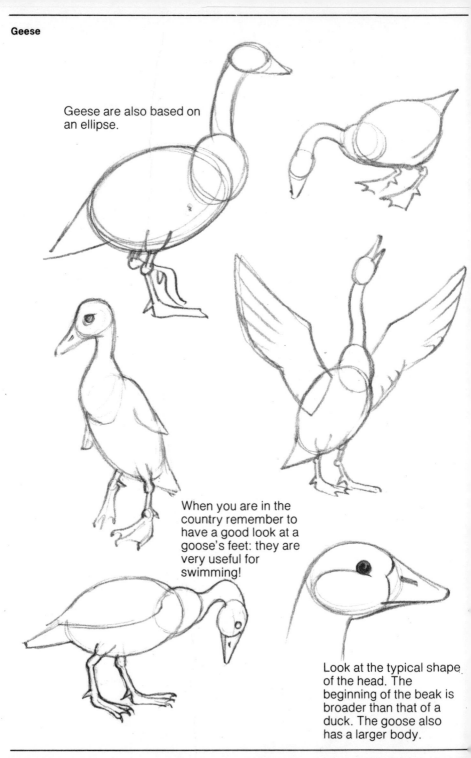

Geese are also based on an ellipse.

When you are in the country remember to have a good look at a goose's feet: they are very useful for swimming!

Look at the typical shape of the head. The beginning of the beak is broader than that of a duck. The goose also has a larger body.

The ellipse has become an egg. Look especially at the position of the legs and the way the goose holds them together when it flies.

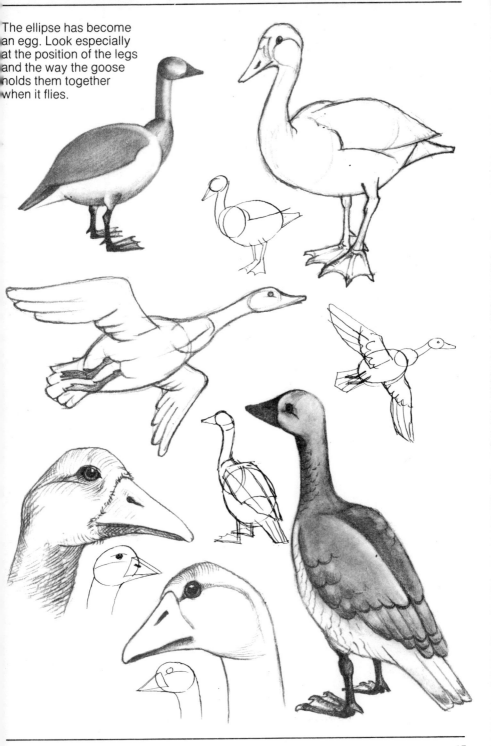

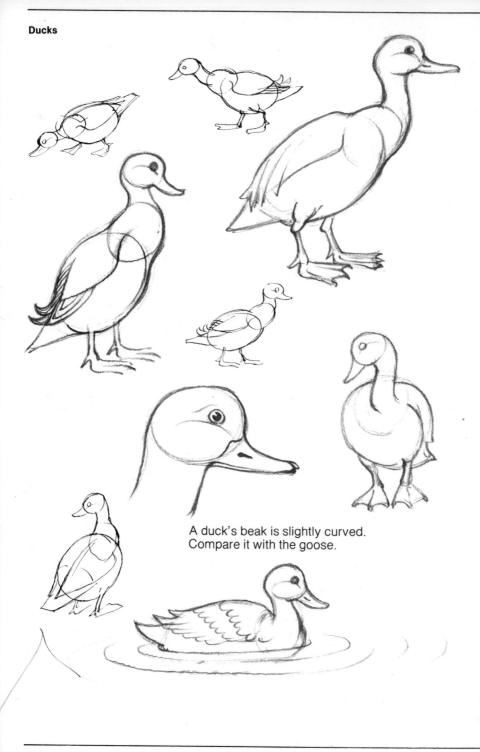

A duck's beak is slightly curved.
Compare it with the goose.

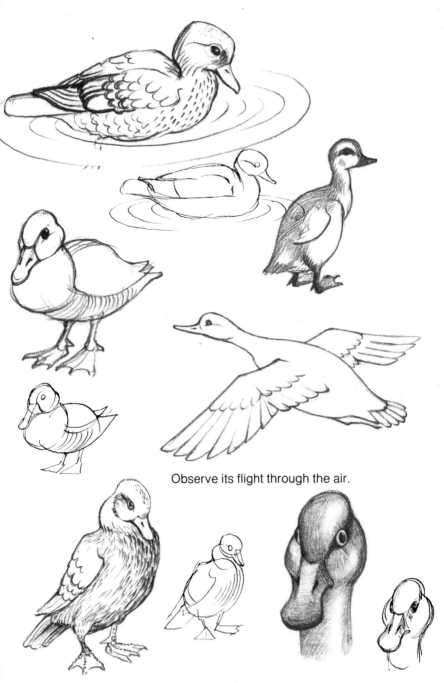

Observe its flight through the air.

Notice the curious way a duck
stands when it is sunning itself.

As we said at the beginning, drawing is by no means an art form which should be left only to the highly talented. Above all, drawing is seeing, and learning to understand what is seen.

This first look at animals will have provided you with the technique and the incentive to observe more closely the shapes in nature and then to sketch them. In further volumes we will use the same techniques while concentrating on other aspects of the visible world.

Printed in Singapore